Unannounced Voices:

Curatorial Practice

and

Changing Institutions

Zdenka Badovinac

Unannounced Voices:

Curatorial Practice

and

Changing Institutions

Thoughts on Curating, volume 2
Edited by Steven Henry Madoff

First Words

I started writing this text two years ago, at the beginning of the pandemic, when we didn't yet know how long it would last, how far-reaching it would be, and how it might change the work of artists, curators, and institutions. Now I'm writing these introductory words more than a month after the Russian invasion of Ukraine in February 2022, just when we thought the virus's grip was becoming less severe and that our lives might soon get back on track.

When the war started, we heard the echo of our incredulous voices that had already proclaimed, with the rise of COVID-19, that the world would never be the same again. Of course, our reaction was strong, as the war was so close to Eastern Europe. But it must be said that this is not the only current war—conflicts continue in Afghanistan, Syria, and Yemen, among other places. War is always present somewhere in the world, as are refugees and their tragic fates. We only began paying attention in Europe when they started knocking on our door in 2015.

It was just in March of this year, at the Democracy Pavilion for Europe conference organized by the museum confederation L'Internationale and ZRC SAZU (Research Center of the Slovenian Academy of Sciences and Arts) and held in Ljubljana, that the artist Nikita Kadan reminded us that the war in Ukraine has actually been going on for eight years. Along with Kadan, several artists and curators from the besieged cities of Kyiv and Lviv added their

voices on Zoom, noting how fragile life is, and that if we want to change this harsh reality we must act here and now. Abstract thoughts will not do.

That this new war instantly became a central theme in Europe—just as the refugee crisis and the pandemic did before—offers evidence of the fact that human tragedies typically become a commodity in cultural and other markets as instruments of capital and politics. In Europe, as in the United States, there has long been a wild cultural war between progressive and reactionary forces, between those who want to use art for greater equality and the democratization of society and those who advocate a return to tradition and emphasize patriarchal and national values.

Cultural war is a continued element of the Cold War, which never truly ended. The aggression of the Russian army in Ukraine has encouraged a boycott of Russian artists and Russian cultural heritage, and thus also threatened their existence. Many Russian artists are resisting Putin's aggression, risking their own freedom and security. True, the incomparable loss of lives, with ever-increasing reports of atrocities, are worse—and we can only hope these horrors will have ended by the time this short book is published. But it is important to say that artists have always spoken out eloquently in the face of war. In fact, even before this disaster in Ukraine, I had already mentioned in this essay the case of some Russian artists who, as you will read, have resisted Putin and his repressive apparatus.

What the whole world wants most right now is change—it's probably our strongest collective wish in this astonishing, difficult time. What is our future, and which voices announce it? Let us say that these can only be situated voices, each with its own body and space, formed through dialogue between different communities and in reaction and resistance to dominant discourses. The call of these situated voices, in rethinking art, curation, and institutions, is the subject of the pages that follow.

It is no coincidence that in Slovene, my native language, the word *glas*, which means "vote"—our most direct participation as citizens in the socio-political sphere—also means "voice," for voices are what connect us to each other as social beings.

A voice is always somebody's voice, and everything you're about to read is my own. It's also a response to what I've heard in the place where I spent most of my time over the past year: my apartment in Ljubljana, in the company of my two cats, my husband, and the many voices transmitted by my computer. The importance of our voices today is made clear every time we click "unmute" in a Zoom meeting; our recent time of COVID-19 lockdowns has reminded us that the presence or absence of our voices connects us with, or excludes us from, a particular community.

Recently, when friends of mine were watching some old television clips of me from thirty years ago, what surprised them was not so much the difference in my appearance as the difference in my voice. It shocked them. Normally, we don't pay so much attention to our voices. We meticulously groom and adapt our physical appearance to suit our various roles, but we don't give much thought to our voice as an extension of our body. Yet the voices we project are also part of our physical selves, and the messages they convey always relate to this concrete physical locus.

Voice is both a medium of meaning and something entirely physical. It serves not only as a metaphor of our unique presence in sociopolitical life but also as a metaphor of participation and interdependence within contemporary curatorial and institutional practices. In this regard, along with talking about *embodied curating*, we could also use the term *envoiced curating*, which underscores the bond to the physical reality of such practices as well as their relational and interdependent nature. Like voice, curating too has performative power—it always creates an effect in real time; its duration doesn't end with some self-contained event. Curatorial practices today occupy the same experiential time and space as the rest of life and are the result of the interaction of voices from every direction: individual localities, different social groups, genders, sexualities, races, ethnicities, and classes as well as a tense sociopolitical situation, which has only been exacerbated by the pandemic.

Now more than ever, it's clear that we simultaneously occupy both physical three-dimensional space and space on the electromagnetic spectrum, the latter through the sound waves of our voices. At the same time, however, it's crucial to understand that our voices don't fully represent our identities, which carry traces of the Other. Similarly, our voices don't entirely convey the meaning of our words, and it's this aspect of voice that doesn't end in meaning—this remainder can't be categorized, as the philosopher Mladen Dolar writes in his book *A Voice and Nothing More*.[1] Dolar underscores the fact that voice per se

exists somewhere between its physical, or physiolog-ical, characteristics and language—that is, between the material and ideal realms, between nature and culture. He reminds us that the human voice can also be replicated by machines, which makes it all the more difficult to define the dividing line between the human voice and other sounds from nature, machines, or technology. He writes, "Civilization announces its progress by a lot of noise, and the more it progresses the noisier it gets."[2] The more noise there is, the more there is that can't be categorized, and the more difficult it is to say where the voice comes from, whose voice it is. Given the noise around us, we have to doubt the authenticity even of voices that are critical of the present situation and demand social change. But while postmodern thinkers have declared that the authentic voice no longer exists, it's difficult to claim that the pain, suffering, and injustice expressed by these voices don't exist. All these struggles certainly do exist, as does the need to eliminate the conditions that cause them. This isn't just an individual need; it's shared by many people, whose voices resonate as a collective voice.

The pandemic we've all been through, and that will likely remain with us, if in a less virulent form, has silenced the noise—at least for a moment—focusing our attention on our immediate surround-ings and those closest to us. Suddenly, we've become more aware of our dependence on local ecosystems

1 Mladen Dolar, *A Voice and Nothing More* (Cambridge, MA: MIT Press, 2006).
2 Dolar, 13.

and the importance of sustainable models of living that allow us to survive within our proximate environment. By ecosystem, I mean the totality of our environs, including nature and culture, plants, animals, and communities of people with common goals, traditions, and knowledge. These sustainable models, however, don't signal a naive return to authentic relations, traditional knowledge, and unspoiled nature, for they themselves are informed by all the civilizational noise in which we live.

What matters today isn't isolated local or traditional knowledge but *situated knowledges*—a term coined more than thirty years ago by Donna Haraway.[3] Referencing her ideas, but also speaking from my own situatedness, I loosely define *situated knowledges* as the varieties of knowledge that arise at the different intersections where we're situated as members of a local or translocal community or environment, whether based on racial, sexual, or ethnic identity, or on political or, indeed, any conceptual affinity. But whatever is the object of this knowledge is also its agent: "Situated knowledges require that the object of knowledge be pictured as an actor and agent, not as a screen or a ground or a resource, never finally as slave to the master that closes off the dialectic in his unique agency and his authorship of 'objective' knowledge."[4]

3 See Donna Haraway, "Situated Knowledges: The Science Question in Feminism and the Privilege of Partial Perspective," *Feminist Studies* 14, no. 3 (Autumn 1988): 575–99, https://doi.org/10.2307/3178066.
4 Haraway, 592.

This is a good moment, I think, to reflect on how the pandemic and its reverberations will likely shape our curatorial practices and institutional work—and, not least of all, art itself. It's essential that we rethink our voices as political instruments and extensions of our bodies. Equally important is that we understand the current time's imposition of distance and our need for closer physical contact. More than ever before, the direct and durable effect of the pandemic is the way that we experience space as always in between, both remote and near, a condition of *situatedness*. This condition is never neutral. It's always a matter of the ways in which we experience our individual environments—as I've already defined environment—and this situatedness must be taken into account in our curatorial and institutional practices. The practices that most interest me in this regard are practices of participation in which we invest our voices to propose a better life. These situated practices have their own place of projected utterance, which is also, simultaneously, the place of listening to voices from everywhere else.

The Local

Despite our constant presence in these in-between spaces, the existing art system still treats us most often as beings whose voices come only from concrete physical localities. It suits the art system to represent and emphasize such places (e.g., the art of Eastern Europe, Latin America, Africa, Asia, etc.), but always in ways that incorporate them into this same system.

Since the beginning of the 1990s, interest in the local has been driven by two opposing impulses. The first follows the dictate of market logic and aims to solidify the existing homogenizing positions of the international art system. For the past thirty years, mainstream curatorship has focused on presenting geographical diversity, but it's essential to note that it's primarily the less powerful, subordinate regions that are marked as geographically particular, while the dominant regions—their institutions and art market—remain above this sort of geographical essentialism. This hegemonic market impulse to represent the art of the Other never really allows the Other to speak with its own voice in a way that exerts influence in a deep contextual sense, and therefore changes nothing.

The second impulse, which opposes the first, is connected to local interests and guided by local emancipatory knowledge and practices that curators and artists rely on when critiquing and challenging the existing state of affairs. In this regard, the most

interesting and relevant curatorial projects are those prepared by curators in contexts and settings that relate specifically to local issues, rather than in major international museums. When it comes to this kind of socially critical non-Western art, prominent institutions have for the most part presented little-known practices and phenomena without necessarily recompensing the local environments from which the art has been taken. Still, it must be said that these big-museum projects do support research and knowledge production that local institutions often don't have the means to undertake or sometimes even recognize as important.

The art system prioritizes the representation of different localities as a way of gaining greater visibility for itself. But increased prominence is also desired by local agents who see it as a necessary condition for participating in the international art system.[5] Such games of representation are, in fact, more reflective of the logic of the system than they are of actual local situations, which exist in a state of constant flux and are always somewhere in between. Formed by the developed Western world, this art system encompasses the long traditions of art collecting, museums, art academies, art history and theory, art publishing, and the art market. And it's this same system that continues to codify and categorize art, seeking to put everything in a known framework to ensure that nothing remains

5 As detailed, for example, in the first volume in this series: Terry Smith, *Curating the Complex & The Open Strike* (London: Sternberg Press, 2021).

undesignated, unlabeled, or without a signifier, for meaning itself has become a commodity. Among other things, the globalization of the art system has allowed the existing centers of power to become even more powerful; to expand their codification to practices from the geographical periphery, or indeed, from any less standardized periphery. Here, of course, it's important to note that locality isn't merely a passive object in these processes of codification. Situated curatorial and institutional work constantly make visible the tensions implicit in these varying approaches to the representation of locality and what it designates.

This process of designation isn't unlike what the Italian Marxist theorist and activist Franco "Bifo" Berardi has described as the alienation of language from the body and the material world. The production of meaning is no longer rooted in the direct communication between people, as that no longer exists—our relations have long been codified by the financial economy. Berardi writes, "Signs produce signs without any longer passing through the flesh."[6] Signs thus produced are deterritorialized and often return to their "home" without ever truly corresponding with what was produced there. Here I'm referring to the complex processes of the abstraction and alienation of language that are stimulated especially by the workings of the media, social networks, and the internet as a whole, through which we lose touch with our individual or collective bodies. How, then, can we reconnect with ourselves and our communities? Berardi writes that language must be returned to the body, and that poetry—and here I would add visual art—has a special role to play in this: "Poetry is a singular vibration of the voice. This vibration can create resonances, and resonances can produce common space."[7]

In our context, Berardi's concept of the alienation of language means the loss of the kind of

6 Franco "Bifo" Berardi, *The Uprising: On Poetry and Finance* (Los Angeles: Semiotext(e), 2012), 17.
7 Berardi, 147–48.

voice that's able to reverberate and create a common space. This common space is what today's curatorial practices strive to generate. Common space can be no longer only a localized space but, as I've described, must be an in-between space in which voices of many registers are situated and resonate. And they resonate precisely because these in-between spaces are in essence fields of closeness—not necessarily thanks to physical proximity, but the immediacy of social connection.

Today, more than ever, the pandemic has brought our mutual interdependence to the forefront, especially our interdependence within a specific ecosystem. As I noted, the pandemic has heightened an interest in the local, which holds our most familiar sense of social connection. "Local" must therefore accommodate the in-between condition of space that I've proposed. This new sense of how locality is communicated isn't simply about bringing visibility to the cultural production of a physical place. It's about creating and spreading more awareness about the strength of particular communities and, beyond this, of community as solidarity, community as the power of interdependence. The clear need for solidarity with and concern for others has today increased our interest in the local, and in any other micro-environment or community.

Situated curatorial practices rely not on the finality of the product or on the ultimate event, but on participation and interaction with their surroundings. Regardless of the medium, the artwork in situated practices is opened up: no longer under the absolute control of the author, it's inherently open to something undesignated, unnamed, which can also be understood as the voice of the Other. Something that's unnamed possesses a certain subversive power, but it can also be the instrument of authority. Dolar illustrates this idea with the example of the logo for the record label His Master's Voice, which showed a dog listening to a voice coming from a phonograph horn. Dolar notes that the point of this image was to persuade customers that the gramophone, a new technological miracle at the time, was so effective at reproducing sound, it could even fool a dog. The dog believes the voice from the gramophone all the more because he doesn't see its source. As Dolar says, "The acousmatic master is more of a master than his banal visible versions."[8]

The problem, then, isn't the degree of visibility or invisibility in situated curatorial practices; more importantly, the emancipatory role of situated curatorship today lies in uncovering the source of the voice and giving it power, returning it to the body. This means that curatorship needs to address the

8 Dolar, *A Voice and Nothing More*, 77.

material conditions of the work. Today, however, it isn't enough to merely describe these conditions; they must also be created. For situated curatorship to do this, it has to create its own provisional infrastructure that allows it to operate as independently as possible. It must strive to create micro-environments that are based on collaborative practices and include different organizations (e.g., small galleries, collectives, NGOs) and environments that aren't fully dependent on the dominant art system or the prevailing economies and epistemologies. The creation and design of the work conditions aren't separate from the content of the work itself; they constantly intertwine with it. Here art isn't merely an object of curatorial treatment: artists are partners in the curatorial process, which, as I noted, is focused not on any concrete artwork as such but on producing subjectivity and creating a different rhythm of life. At this point, we need to ask to what extent, if at all, the traditional division of roles within curated projects is still sustainable.

The Work

Art is work—and work of different kinds. But in art, work has its own voice. Artists long ago ceased to be merely painters, sculptors, photographers, etc. Today, we find them in many different roles. On the one hand, this is because they're forced to do different things for their livelihoods. On the other, it's because art itself has expanded into different disciplines and social roles. This shift, of course, has its history.

In the 1960s, institutional critique and other new artistic practices brought about processes that began to erode the established division of roles in art projects. Conceptual artists started documenting their art actions as they performed them, and these documents were then left behind as either artistic artifacts or archives—a dilemma, in other words, concerning the identity of these documents and the boundary between art and archive. This, in turn, raised questions about the boundaries between artist, curator, and archivist. Every new shift in society added its own specific twist to these questions.

To illustrate how collaborative art practices were transformed in the 1990s, I will use the example of Slovene cultural organizations. Not long after Slovene independence in 1991, the government supported the establishment of cultural nongovernmental organizations and began funding their projects. These NGOs included small production houses, galleries, modern dance theaters, small

publishers, and so on, mostly run by artists. Almost without exception, these organizations were the heirs of local avant-garde traditions and their ways of working.

While art collectives under socialism had a utopian character, artists in the 1990s stopped fighting the machinery of history and ideology and began fighting more pragmatically for their own survival. They became producers, curators, archivists, and administrators in their own small professional organizations. The government's cultural policy set the norms for these new NGOs, including the number of projects they could realize each year, their timetables, and other details, essentially making them subject to the logic of project work. For many in the cultural field, this meant they could make a living only as long as the project lasted, and so they joined the growing ranks of precarious workers. While it would be difficult to say there were better working conditions under socialism, it's a fact that artists were masters of their own time, free from the demands of funding agencies. Finding themselves part of various project groups, artists and other cultural workers in the 1990s began to take on the roles of organizers, administrators, technicians, and whatever else a project demanded. All of this migrated into the art itself through the voices of artists working under precarious conditions. In other words, artists didn't blindly agree to the given conditions but instead began to critically stage their work and their roles in this work. Consequently, the format of the artwork also began to change: it took

the form of actual reading rooms, bars, video libraries, solariums, sports fields, and so forth. Naturally, this also influenced curatorial practices. No wonder that the roles of curator and artist were increasingly intertwined.

This intertwining of roles in the creative process is, in its own way, a continuation of the avant-garde practice of merging art and life. Yet it's also an expression of the precarious ways of working that have erased these boundaries. In her book *Artist at Work*, Bojana Kunst makes a theoretical distinction between work per se and the kind of project work that has become the core of the post-Fordist mode of production.[9] Projects subject us to deadlines and seep into the pores of our lives so that we have no time for deeper social experiences that, as Kunst says, happen only through extended contact with reality. The precariousness of project work only intensifies with each new project, especially in times of crisis, such as during a pandemic. Today, as so often in history, a time of crisis has revealed the need for various agents—artists and other precarious workers, institutions, and activists—to form a united front to oppose the alienation of work and the capitalization of time.

9 Bojana Kunst, *Artist at Work, Proximity of Art and Capitalism* (Winchester, UK: Zero Books, 2015).

Over the past few years, we've seen the spread of protests in resistance to the neoliberal order, which threatens not only our work but the entire planet, and in opposition to the rise of local autocratic regimes.

In 2010, we saw the beginning of the Arab Spring demonstrations, which were followed by similar movements across the globe, from Occupy Wall Street in 2011 right up to today's protests against new authoritarian regimes in Europe. Throughout this time, social media platforms have been at the core of these resistance movements, resulting in some cases—such as during demonstrations in Egypt, Bahrain, Libya, Hong Kong, Russia, Belarus, Myanmar, and elsewhere—of punitive government efforts to block or ban internet and mobile connections for strategic periods of time. Whistleblowers like Edward Snowden and Julian Assange, as well as various hackers, have become true heroes for our times. What's more, today anyone can be a hero: the international hacker group Anonymous, for example, lets anyone adopt their name, provided the person is willing to take the risk. Before the pandemic, the most notable of these worldwide protests were about climate change and gained added strength thanks to Greta Thunberg's activism. Despite the pandemic, people haven't stopped protesting, especially against local authorities. But faced with COVID-19 restrictions, protesters have had to be more resourceful, more creative: they draw

crosses, squares, footprints, and other markings on the ground to indicate the mandated social distance. Today even the smallest gesture that contributes to the preservation of public space is a heroic gesture. All these heroes not only stir our admiration but, more importantly, restore our hope in our own power. They renew our faith in the idea that every individual can make a difference when they're prepared to make some sacrifice for the sake of the common good.

These protests seek to support the common good and expose the common evil, an evil that today connects the entire world. In many cases, the art in these protests—and more generally, art in public spaces—links similar kinds of issues in different contexts, even when the protests appear to be focused solely on local issues. In this regard, one of the more provocative projects attracting recent attention is Péter Szalay's sculpture *Black Lives Matter*, which was among the winners of a public art competition in Budapest at the end of 2020. A rendition of New York's Statue of Liberty, Szalay's work presents Lady Liberty in rainbow colors, kneeling and holding a tablet with the inscription "Black Lives Matter." Even before the work was realized, it was condemned by Viktor Orbán's nationalist right-wing government. The mayor of Budapest's ninth district, Krisztina Baranyi, came to its defense, saying, "The BLM goals of opposing racism and police brutality are just as relevant in Hungary as anywhere else." She connected the sculpture's message with the Orbán government's policies against migrants and refugees, as well as its systematic discrimination against Hungary's Roma population.[10] As the Black Lives Matter

10 Quoted in Shaun Walker, "Budapest Black Lives Matter Artwork Sparks Rightwing Backlash," *Guardian*, January 5, 2021, https://www.theguardian.com/world/2021/jan/05/budapest-black-lives-matter-artwork-rightwing-backlash.

movement has spread around the world, it has been instrumentalized by various local political causes, each in its own way. Similar to Orbán, Slovenia's nationalists, in an article on the website of one of their pro-government mouthpieces, described Black Lives Matter as a movement that seeks to destroy the foundations of Western civilization, calling it anti-family, pro-abortion, and pro-homosexuality.[11]

There's no question that Black Lives Matter and other social justice movements are influencing both art institutions and curatorial practices. This is most often seen in the increased inclusion of discriminated and marginalized groups, as I highlighted earlier in connection with geopolitical issues. But let me reiterate: the inclusion of marginalized regions and social groups does not in itself lead to fundamental changes. The most powerful method of inclusion is the "political correctness" principle, which serves as an ethical adjudication of various past and present wrongs, at times acting preventively as well as setting work norms in advance. Thanks to the pervasive practice of politically correct social policing, there are growing numbers of participants

11 In June 2020, the headline of an article on the website of the right-wing news outlet Nova24TV stated, "Black Lives Matter is not merely against discrimination—it is an anti-civilization organization that supports abortion, homosexuality, and anti-family values." See Jani Kos, "Black Lives Matter niso zgolj proti diskriminaciji—je anticivilizacijska organizacija, ki podpira abortus, homoseksualnost in protidružinske vrednote," *Nova24TV*, June 15, 2020, https://nova24tv.si/svet /black-lives-matter-niso-zgolj-proti-diskriminaciji-je -anticivilizacijska-organizacija-ki-podpira-abortus -homoseksualnost-in-protidruzinske-vrednote.

from discriminated and marginalized groups, and social justice movements have benefitted from a more politically correct use of language. Similarly, underscoring the importance of solidarity and collective struggle, the #MeToo movement created a cultural shift and called attention to the sexual abuse of women.

None of this should be underestimated. Political correctness has a real influence on people's actions, raising awareness of proper behavior while offering new means to enforce exclusion. We also see nonsensical and exaggerated decisions made in the name of political correctness. Here I'll refrain from commenting in detail on the violent removal of monuments or the exclusion of certain problematic works from museum collections. I'll only say that exclusion and inclusion follow a similar logic. Still, we have to wonder how much these efforts are truly shaking the foundations of the global capitalist system that again and again turns a blind eye, obfuscates, and covers up, making way for more injustice and inequality.

As I noted at the outset, the thinking about situated curatorial practices must itself be situated. My aim isn't to offer some objective overview of such practices worldwide; instead, the local case studies I describe are intended to help us understand a common evil—the global force of capital—and how it's expressed in various places. Because I grew up in a socialist country, during the pandemic I couldn't help but reflect on public health and education then and now, on old and new autocracies, on culture wars and the rights of workers. The current situation may still be described, conditionally, as *postsocialist*. This term may be applied not just to former socialist countries but to the entire world. And although the world has been caught up in the maelstrom of neoliberalism for decades, there still remains for us in Eastern Europe the living memory of a time when we enjoyed a society of solidarity, just as we remember a time when we thought that living in freedom meant living the way people did in the West.

There can be no doubt that the countries that performed better during the pandemic are those that made larger investments in public health, public education, nursing homes, democratic culture, and other necessities related to the common good. Nevertheless, in Eastern Europe, the proponents of neoliberalism too often view the welfare state as a remnant of socialism, and they bolster their attacks on it by denigrating the

past and fomenting culture wars between left and right, between the heirs of socialist values and the adherents of nationalistic, patriarchal values. In the process, they increasingly resort to extreme rhetoric and hate speech. As a result, socialism has become an almost meaningless word, to the point where it seems that virtually nobody wants to engage seriously with it—except artists!

Artists and many other cultural workers in Eastern Europe are responding to this right-wing demonization of socialism, which is largely an attempt to obscure ever more blatant authoritarian gestures in the broader region, where media freedom and the freedom of expression are shrinking; where politically based staff changes are taking place in public cultural institutions; and where the work of artists and NGOs is made ever more difficult, if not impossible. In former socialist countries, artists and cultural workers are still dependent on state support for their livelihoods since the art market remains largely nonexistent, while local oligarchs prefer to invest their money in prestigious international collections rather than create socially responsible foundations for supporting artists and their work. In Eastern Europe, especially in the countries of the former Yugoslavia and in Russia, some artists are warning against the ideological erasure of socialism's positive aspects, particularly because those aspects might well help us address the problems of our era. At the same time, these artists maintain a critical distance to the former socialist regimes that largely betrayed socialist ideas by subordinating them to

autocratic power. Additionally, it's important to distinguish between different versions of socialism, especially between the self-managed socialism of Yugoslavia and the centralized socialism of the Soviet-bloc countries.

Over the past thirty years in the countries of the former Yugoslavia, an informal cultural network has developed that's devoted to preserving the emancipatory traditions of socialism. In 2009, the Museum of Yugoslav History in Belgrade hosted the exhibition "Political Practices of (Post)Yugoslav Art," which was prepared by four organizations from different parts of the former Yugoslavia: Prelom kolektiv in Belgrade; WHW (What, How and for Whom) in Zagreb; kuda.org in Novi Sad; and SCCA/pro.ba in Sarajevo. The exhibition focused on the emancipatory tendencies of the Yugoslav postwar avant-garde, socialist modernism, and Partisan art. One of its goals was to oppose the dominant historical representations of Yugoslav art and culture, as well as the socialist sociopolitical system in general. Developing work that deals with the former Yugoslavia is becoming more and more of a subversive act.[12]

Although the Belgrade exhibition was devoted specifically to Yugoslav political practices, the organizers also invited the Russian collective Chto Delat (What is to be done) to participate. They created a video, *Partisan Songspiel: A Belgrade Story*, which looks back at the emancipatory Yugoslav Partisan tradition as it comments on the twenty-first-century Serbian government's capital-driven oppression of the Roma population. Like the ex-Yugoslav artists,

the Chto Delat collective, which includes artists, critics, philosophers, and writers, is similarly interested in examining how the socialist legacy can be applied to today's problems. They describe their work as follows: "The activity of the collective takes responsibility for a postsocialist condition and the actualization of the forgotten and repressed potentiality of the Soviet past," often "as a politics of commemoration."[13]

One of their early actions, *Angry Sandwich-People, or In Praise of Dialectics* (2006), commemorated the centennial of the Russian Revolution of 1905. It was carried out on Ploshchad Stachek (Strikes Square) in St. Petersburg—the same square from which workers marched on the Winter Palace in 1905.

12 An example of this can be seen in the way the Slovenian ambassador to Italy recently reacted to the exhibition "Bigger than Me: Heroic Voices from the Former Yugoslavia," which I curated for MAXXI (the National Museum of Twenty-First-Century Arts) in Rome. Ambassador Tomaž Kunstelj issued a statement in which he said that the embassy would not support or promote the "controversial and scandalous" exhibition because it included artists from other parts of the former Yugoslavia and not only Slovenian artists; he called it "a mockery" of Slovenia's thirtieth anniversary of independence. His statement has received support from both the Ministry of Culture and the Ministry of Foreign Affairs. The controversy has been widely reported on; see, for example, P. G., "Veleposlanik in ministrstvi nasprotujejo rimski razstavi umetnikov iz nekdanje Jugoslavije" [Ambassador and ministries oppose Rome exhibition of artists from the former Yugoslavia], *MMC* (the Multimedia Center of Radio-Television Slovenia), January 25, 2021, https://www.rtvslo.si/kultura/vizualna-umetnost/veleposlanik-in-ministrstvi-nasprotujejo-rimski-razstavi-umetnikov-iz-nekdanje-jugoslavije/549931.

13 Statement from the home page of the Chto Delat website, accessed February 20, 2021, https://chtodelat.org.

Members of Chto Delat, joined by participants from two other activist groups in the city, wore sandwich boards on which they wrote Russian translations of lines from Bertolt Brecht's great poem "In Praise of Dialectics." As the performers moved around, the text was constantly being rearranged, making it impossible to read the poem as a whole. The poem in its entirety could only be heard: declaimed in typically Soviet fashion, the lines resounded with the pathos of the revolutionary past. By adopting the role of placard-wearing protesters, the performers drew attention to the way workers were treated in Soviet times and the way they're treated in Russia today. In Soviet propaganda, someone who earned money in a capitalist society by wearing sandwich-board advertising was the symbol of "the utmost exploitation of a person's living labor," while in present-day Russia nobody sees it as a problem.[14]

Chto Delat's action took place at a very specific, historically marked location, but what truly situated the event was the materiality of the declaiming voice. Furthermore, the voice that was physically present was also an absent voice—a *Soviet* voice. And this voice from the past introduced a Brechtian alienation effect, which broke the illusion that Russian protests could lead to any real change. At the same time, the constant reconfiguration of Brecht's poem pointed to the dialectic of history and, therefore, to the eternal potential of revolution.

14 See the description of the project on the Chto Delat website: "Gnev cheloveka-buterbroda (2006)," https://chtodelat.org /ar_2/гнев-человека-бутерброда-2006.

In many Eastern European countries today, the most potent art is being made on city streets, where art joins in solidarity with protesters critical of authoritarian power. We see demonstrations happening regularly in Russia, Ukraine, Belarus, Poland, Slovenia, Romania, Hungary, Serbia, and elsewhere. The demonstrators are protesting against the poor conditions in which they work and live, their corrupt local politicians, and ever-greater constraints on freedom of speech. They're also concerned about environmental issues, refugee issues, and other disadvantaged and marginalized social groups, including artists.

The most radical activist-artists can currently be found in Russia, not just because of the severity of the situation there, but also because of the strong anarchist and activist traditions of Russian art. Perhaps more than anywhere else, the division of roles I mentioned earlier has long been ignored in Russian demonstrations. There, as soon as artists take to the streets, they become social workers and political activists—their disregard for the formal art system is total. The demonstrations themselves are no longer only demonstrations; in a peculiarly Russian way, they become *monstratsii* (monstrations), a kind of public performance that takes place throughout Russia every year on May Day. At first glance, the slogans on the participants' signs seem absurd and apolitical.

They remind me of Andrei Monastyrsky's Collective Actions group in Moscow, which staged a series of actions titled *Slogans* in 1977. Devoid of any clear meaning, the Collective Actions slogans alluded to empty political rhetoric, Soviet agitprop, and ideological gibberish. Written on banners that members of the group displayed in snowy fields in the countryside, the words were stripped of all real content and meaning, so that only the form remained. Interestingly, the Russian philosopher Alexei Yurchak connects today's monstrations with the Slovenian art collective Neue Slowenische Kunst (New Slovenian Art) and their principle of over-identification, namely, exaggerated identification with the object of criticism.[15] Yurchak interprets the word *monstration* as a combination of demonstration and monsters. He notes that participants in monstrations carry signs with apparently "absurd, meaningless and disconnected" slogans, citing examples such as "Let us turn English into Japanese," "We support same-sex fights," "No one has arrived," and "I demand meaningful slogans." Yurchak writes: "At first glance this event is utterly apolitical and nothing more than a meaningless carnival. However, closer scrutiny shows that

15 Neue Slowenische Kunst (NSK) was founded in 1984 by
 three groups: the multimedia group Laibach (established
 in 1980), the visual arts group Irwin (1983), and the Sisters
 of Scipio Nasica Theatre (1983–87). At the same time, the
 collective created a fourth group, the graphic design studio
 New Collectivism. Later, other divisions were established:
 the Department of Pure and Applied Philosophy, Retrovision,
 Film, and Builders.

monstrations work as a powerful form of political critique in the context of late-Putin rule."[16]

Monstrations, as another form of unannounced and quicksilver voices, began partly for strategic reasons, to avoid criminal charges and imprisonment. The most notorious cases of prosecution against Russian activist-artists have involved the street-art group Voina (War), the feminist punk-rock and art group Pussy Riot, and the artist Pyotr Pavlensky. For years, artists in Russia have been fighting for freedom of speech and other civil rights and against Putin's politics, which favor traditional patriarchal values. Here I should also mention in particular such feminist women artists as the Nadenka Creative Association, Katrin Nenasheva, and the Shvemy Sewing Cooperative. As Tatiana Volkova writes, these artists "promote a feminist agenda, e.g., fighting domestic violence, counteracting patriarchal institutions, supporting minorities and repressed groups." She goes on to note, "This art does not usually appear in the gallery but rather surfaces on the streets in alternative formats such as social networks, graffiti, home videos, and private publishing."[17]

16 Alexei Yurchak, "Monstration: The Absurd as Political Critique," abstract of a lecture delivered at the international conference at Moderna galerija, Ljubljana, held in conjunction with the exhibition "NSK: From *Kapital* to Capital: Neue Slowenische Kunst, An Event of the Final Decade of Yugoslavia," June 21, 2015; the program is available online, http://nsk.mg-lj.si/wp-content/uploads/2015/05/NSK-Conference-programme-contributors.pdf.

17 Tatiana Volkova, "The Chronicles of the Russian Activist Art," *Widewalls*, March 3, 2017, https://www.widewalls.ch/magazine/russian-activist-art-chronicles.

So how do we situate the curator in this context? We know that street art is normally self-organized, in contrast to the curated art programs of institutions. But it's worth asking if the principles of self-organization and the negation of the usual division of roles are now so widespread in art that they're actually influencing the work of institutions. And not only that, but how much can institutions be part of the same struggle? Consider the situation in Poland, where the authoritarian shift occurred in 2015 and continues today. It's characterized by a shrinking democracy, fascist impulses, a hatred for those who are different, discrimination against minorities, a ban on abortion, and constrictions on the rights of the LGBTQ community. Protesters are calling for measures to uphold democracy and diversity, and to protect the legal system from political influence. They're also concerned about environmental issues and protections for minorities, journalists, and women. One of the most important protests is the Ogólnopolski Strajk Kobiet (All-Poland Women's Strike), which fights to defend the right to abortion and women's rights in general.

While the protests and artists' street actions in Russia and elsewhere have been mostly self-initiated, without the discernable support of any institutional structures, in Poland we see efforts toward more structured collaborations. Here, of course, I'm speaking about these approaches primarily in connection with art activism and how current turbulent events might be reflected in curatorial and institutional practices. For example, much has been done in this

regard by the Office for Postartistic Services (OPS), a self-organized group of artists who operate as part of the Warsaw-based nongovernmental Bęc Zmiana Foundation. OPS, which recently evolved from the informal art-activist network Consortium for Postartistic Practices, represents a different model of horizontal collaboration, one that includes both nongovernmental and institutional partners as well as individuals. This infrastructural form is better able to serve the new methods of cultural production than traditional forms: it provides a certain protection for self-organized and more vulnerable kinds of cultural production based on their own economies.

In their effort to counter alt-right propaganda, OPS (and the consortium that preceded it) supports activities outside gallery walls: on the streets and in the media. Their most monumental action to date is "The Anti-Fascist Year" (2019–20), a countrywide initiative promoted by a coalition of public institutions, NGOs, social movements, art collectives, individual artists, and activists. By providing an infrastructure for the horizontal collaboration between artists, cultural workers, activists, and social movements, OPS presents a good model for the future of art institutions, which will need to connect more and more with other noninstitutional entities, given politics as it stand now and a pandemic-stricken world.

There has also been an authoritarian shift in
Slovenia—it happened on March 1, 2020, one day
after the government declared that the country was
officially experiencing a pandemic. The COVID-19
pandemic then became an excellent opportunity for
the escalation of hate speech, stricter immigration
policies, and new pressure on the media and cultural
institutions. The government is taking out its anger
especially on artists, independent cultural workers,
and NGOs. At the same time, critically minded
intellectuals and artists are increasingly facing
retribution while populism and patriarchal values
are being strengthened. In the spring of 2020, not
long after lockdown measures were first introduced,
people staged spontaneous protest actions on their
balconies, Ljubljana was covered in anti-government
graffiti, and, in the city's parks, people could be
seen wearing not just athletic gear but also protest
messages on T-shirts, caps, and other garments.
By late April, protesters took to their bicycles
to demonstrate—it was the only way they could
follow the recommended social distancing rules for
protection against the coronavirus. These weekly
demonstrations, which have been going on for more
than a year almost without interruption, are aimed
against the current government, corruption, police
violence, militarization, capitalism, and environ-
mental destruction.

All sorts of people from every generation can be found among the protesters. Yet it's the representatives of the anti-capitalist bloc, the anarchists, and Antifa who give the demonstrations a particular tone. A core group is the Workers in Culture Task Group (Aktiv delavk in delavcev v kulturi), whose members wish to remain anonymous, partly for security reasons. They're the ones responsible for the visual identity of the protests. Their participation in the protests is also the most (self-)curated, if we can use that term, since they create the rhythm and repetition of certain actions that closely resemble performance art. These actions also have their own visual identity, with a stenciled bicycle as their logo. The actions/performances convey a clear message and avoid any complex, multilayered content; their aim is social criticism and agitation. Visual markers of the protests, and the actions that accompany them, are placed in precise locations and use the specific features of the spaces they occupy.

One of the most striking visuals is a graffiti work showing a five-hundred-meter-long line of bicycles that extends along the walls next to the Gradaščica River channel in Ljubljana. It was created in a mere forty minutes by two groups using stencils, according to what artists told me. During the pandemic, the protests have been the only regularly occurring large-scale cultural events in Ljubljana that have maintained social interaction and collective expression through the presence of bodies, whether on bicycles or some other way to ensure social distancing. The protests have elicited

both powerful emotional responses and critical stances, from which a sense of collective belonging has increasingly developed. Significantly, the bikes in the graffiti along the Gradaščica have no riders: they represent a silence, an empty signifier any voice can fill. The absence of the cyclists' individual bodies helps us to assign that sense of belonging to a collective body.

From the earliest days of modernism, a battle has been waged between those who believe that art should change reality and those who are opposed to any utilitarian approach to art, instead advocating its autonomy. But if anything has succeeded in denying art both its active role in changing reality and its autonomy, it's today's post-Fordist production. Having subordinated the complexity of our lives to the principle of work, and having crept into our subjective selves as the ultimate curator of our lifestyles, post-Fordist production has succeeded in completely uniting art and life. While artistic form and curated lifestyles have now been integrated into the dominant mode of production, protest or propaganda art is fundamentally different: it takes clear positions. Post-Fordist production absorbs and plays with different artistic languages, but does so without taking a position toward society and its problems. In post-Fordist production, we're dealing with an empty, postmodern combination and juxtaposition of different forms, while in contemporary artistic and curatorial practices, we see an intermingling of diverse genealogies and a desire to change reality. Meanwhile, these diverse genealogies are accompanied by interdisciplinary practices and a fluidity between different roles, as well as new ways of (co)producing knowledge.

In late 2013, the Van Abbemuseum in Eindhoven, the Netherlands, presented the project

"Museum of Arte Útil," conceived by the artist Tania Bruguera. The project was announced as "a place where art's use value and social function will be analysed, initiated by the artist Tania Bruguera, developed with the Van Abbemuseum and constructLab and realised by its users."[18] The exhibition presented an archive of different practices that understand art as a tool or device that helps us develop alternative tactics for our work in society. Certain projects were activated by the users of the museum, while others served as a basis for analysis and debate. Some were presented in real time, such as "The Honest Shop," created in collaboration with the Grizedale Arts organization from the English town of Coniston in the Lake District. The organization is based at the Coniston Institute, which was founded in 1852 as the Mechanics Institute with the aim of promoting lifelong education and learning for local miners and industrial workers and their families. John Ruskin, who lived in Coniston, was central to the institute's development. Grizedale Arts is committed to this legacy, reviving the region's rich artistic, artisanal, and agricultural tradition as a means to develop an alternative institutional model. Created in collaboration with the Coniston community, "The Honest Shop" took on a second life with the "Museum of Arte Útil," which set up an Honest Shop booth as

18 "Exhibition: Museum of Arte Útil," Van Abbemuseum, 2013, https://vanabbemuseum.nl/en/programme/programme /museum-of-arte-util/.

part of Dutch Design Week, in effect pairing two distinct local traditions: design from Eindhoven and food and crafts from Coniston.

Even the title of the exhibition, "Museum of Arte Útil," tells us we're dealing with a proposal for a different kind of institution. It's hardly a coincidence that the project was developed as part of the program of the museum confederation L'Internationale, which serves today as the model for a different form of museum—one that aims for long-lasting collaborations that transcend the logic of one-time events.

L'Internationale is a confederation of European art institutions that seeks to develop a European museum based in seven venues in six different countries that operate transnationally—that's to say, somewhere in between these localities.[19] Begun in 2010, the confederation has committed itself to working with neglected histories, developing a common knowledge, opposing hegemonic positions, and respecting horizontalized partnerships as fields of resonance. The seven institutions adhere to this new form of international collaboration, bringing together museums and smaller organizations, activists, environmentalists, and experts from various sociological and scientific fields in programs that rely on research and connect different social energies. These projects present an alternative to the dominant forms of inter-institutional collaboration, which are largely based on blockbuster exhibitions that serve the society of the spectacle and its singular events.

19 The members of L'Internationale—the Museum van Hedendaagse Kunst in Antwerp, the Moderna galerija (MG+MSUM) in Ljubljana, the Van Abbemuseum in Eindhoven, the Museu d'Art Contemporani in Barcelona (MACBA), the Muzeum Sztuki Nowoczesnej in Warsaw, the SALT Research and Programs in Istanbul and Ankara, and the Museo Reina Sofía in Madrid—as well as its partners, the National College of Art and Design (NCAD) in Dublin and the Valand Academy at University of Gothenburg, are presenting more than forty public activities, including conferences, exhibitions, and workshops, between February 2019 and May 2022.

L'Internationale has completed two multiyear programs so far, and it's currently in the midst of the third—all of them supported by funds from the European Union. In the first program, "Art from the Decline of Modernism to the Rise of Globalization" (2010–12), L'Internationale researched postwar avant-garde movements, particularly those in marginalized areas. This wasn't an attempt to present some counternarrative; rather, the program inaugurated the idea of *multinarrativity* as one of the confederation's key concepts. Working together, the museums prepared different exhibitions, each one composed of works from their own collections and archives, while simultaneously organizing conferences, workshops, and publications. All were done with the desire to deepen knowledge of local histories and rhizomatically connect less familiar histories and regions.

The second program, "The Uses of Art" (2013–18), included the "Museum of Arte Útil," continuing the research into less familiar histories, while rethinking and reassessing the active role of art in society—its use—at a time when it seemed that nothing more could be done. And now the third program is underway, with L'Internationale's institutions and their partners producing "Our Many Europes" (2018–22), conceived at the time of the refugee crisis and other heightened tensions in Europe. Because of the pandemic and increasing social tensions, it became clear that the museums needed to make a complete turn from institutional critique to more concrete work with society.

The member institutions have been developing new programs and adapting old ones in order to express greater concern and solidarity, especially in connection with museum workers and artists who have found themselves without work or income because of COVID-19. Solidarity can't be emphasized enough in describing the spirit of L'Internationale, with several of its member museums operating under increasingly authoritarian regimes. Regardless of how this story plays out, we can say that transnational connections remain vitally important, especially for those working under difficult conditions because of politics, economics, or other reasons.

Here let me mention a lesser-known transnational project, one that brings together curators and artists from Africa, Asia, and Europe. "As you go … roads under your feet, towards the new future," begun in 2020, was conceived by the independent curator Biljana Ćirić, who divides her work between Serbia, China, and Australia. The project connects people from regions that have in some way been affected by China's Belt and Road Initiative (BRI), which is also known as the New Silk Road. One of the world's most ambitious infrastructure projects, BRI involves some seventy countries, predominantly in regions along the historical Silk Road, where China is building roads, railways, and other infrastructure—and substantially expanding its global economic and political influence.

The following organizations, institutions, and people were until recently involved in "As you go": What Could/Should Curating Do? (WCSCD)

in Belgrade; the Moderna galerija in Ljubljana; the Rockbund Art Museum in Shanghai; the Times Museum in Guangzhou; ArtCom in Astana; Robel Temesgen and Sinkneh Eshetu in Addis Ababa; and the Public Library in Bor, Serbia. With contemporary Chinese colonialism affecting the economic and social conditions of these regions, the traditional appearance of cities and established ways of living and working are being transformed. The localities of "As you go" have all been impacted by BRI, and they share historical features as well. A large part of the world along this road was once socialist—the former Soviet republics of Central Asia, the countries of the former Yugoslavia, and Ethiopia. Paradoxically, the only country in "As you go " that remains officially socialist today is China, the builder of the road. It's worth noting that the economies of these formerly socialist countries used to operate far more independently. The copper mines in Bor, Serbia, for example, were an important part of the Yugoslav industrial sector, which underpinned the country's sovereignty. Now, however, the mines are under Chinese ownership.

Ćirić, the project's chief curator, proposed to her partners in the initiative that they connect their research with the writings of the Hong Kong philosopher Yuk Hui and his theory of *cosmotechnics*, a new paradigm that goes beyond the nature/culture divide and seeks to reconcile technology with nature.[20]

20 See Yuk Hui, "Cosmotechnics as Cosmopolitics," *e-flux journal*, no. 86 (November 2017), https://www.e-flux.com /journal/86/161887/cosmotechnics-as-cosmopolitics/.

This theory argues for the situatedness of technology and knowledge in order to oppose the instrumentalization of technology by the dominant global powers. A group at the Ljubljana art journal *ŠUM* (Noise) responded to Ćirić's suggestion by applying Hui's ideas to the Bor copper mines and examining their situatedness in their environment and in social history. The *ŠUM* group took the Bor mines as a case study of local cosmotechnics and offered reflections on how this tradition differs from the dominant contemporary techno-scientific paradigm that we see in the BRI. As the group noted, their aim was not to reaffirm "local premodern cultures and technics (which in themselves are products of modern epistemologies, whether affirmative or reactionary) but rather to question the unilateral development of modern technology, politics and epistemologies."[21]

21 Robert Bobnič, Kaja Kraner, and Tjaša Pogačar, "Bor Is Burning," part of "On Cosmotechnics and New Geopolitics," WCSCD, accessed February 21, 2021, http://wcscd.com/index .php/projects/on-cosmotechnics-and-new-geopolitics/.

In all the examples given, we repeatedly encounter the same question: What kinds of curatorial practices and what kinds of institutions can best serve our unstable world? The primary condition for any serious change to the dominant art system is the development of new formats for institutional and curatorial work that aren't wholly dependent on large budgets or curators with top-tier professional training and education. The fact is that most parts of the art system aren't so privileged, just as most of the world lives in deprivation and poverty, dominated by colonizers and local autocrats. We're also all gripped by the pandemic, with its own downward pressures on economies that have relentlessly cut back cultural support. Furthermore, large parts of the world are dealing with armed conflict and war.

One of the longest and most brutal of these wars is in Syria, where surely the last question on people's minds is: How do you curate an exhibition? Or even: How do you make art? Nevertheless, extremely interesting art and cultural production are found there today, especially in the autonomous region of Rojava in northern Syria, in the eastern part of Kurdistan. Nothing could speak more strongly to the notion of unannounced voices calling out. Rojava's self-managed society represents an extraordinary social experiment: developed under impossible conditions, it respects the values of contemporary democracy, including environmental

values. Once more in history, we see the close symbiosis between artistic and social experimentation. In 2015, the Rojava Film Commune was established; intended not only for professional filmmakers, it also includes a film academy with classes taught by local and foreign experts. Working with the Rojava Film Commune, the curator iLiana Fokianaki organized the exhibition "Forms of Freedom," which included a selection of films from the commune's vast archive.[22] These films, made by both individuals and groups, show not only life in the midst of war but also the collective aspirations for a better society. They were made for the Kurdish, Assyrian, and Arab communities in the region, all of them speaking different languages.

No doubt this is why the film festival organized by the commune in the city of Kobanî included old silent films, Charlie Chaplin's among them, which were chosen for their immediacy and humor, as well as to bridge language barriers. Humor, certainly, works in a very direct way, and silent humor, in which our different languages are muted, may be the medium through which we best understand each other. In this case, silence essentially appears as the collective voice, whose significance lies not in the harmonization of difference, but in the revelation of silence as otherness—as an otherness that exists within all of us. Not for the first time in history,

22 As of this writing, the exhibition "Forms of Freedom" has been presented at the nonprofit art institution State of Concept Athens, Galerija Nova in Zagreb, e-flux in New York, and MG+MSUM in Ljubljana.

film again proved to be a tool for activating the emancipatory potential in society. Lenin himself, who called film the most important form of Bolshevik art, understood what a powerful medium it could be for propaganda, agitation, and education, especially in Soviet Russia in the early 1920s, when most of the population was illiterate.

The idea that art should care about people is hardly new. But with the pandemic, we began to uncover new dimensions of care. Here posthumanist and feminist theorists are particularly insightful: they ascribe care to human agency, while insisting that nonhuman agency must play a key role, too. They also give great importance to the traditional care-giving role of women—which is largely unpaid—and to various community and Indigenous practices. A significant part of contemporary art and curatorship seeks to make these facts more visible. María Puig de la Bellacasa, one of the more quoted writers on posthumanist topics in the art world, defines care "as a concrete work of maintenance, with ethical and affective implications, and as a vital politics in interdependent worlds."[23] Similarly, art and curatorship, by making connections between ethics, politics, and practical work in their focus on care, are contributing to an ecosystem that helps to sustain life and society.

As noted earlier, micropolitics often fills the gaps where macro social systems fail. Some art groups and activists have transformed themselves into social workers. In many cases, they work on the fringes of the law, or even outside it, and as a result are being persecuted by the authorities. This

23 María Puig de la Bellacasa, *Matters of Care: Speculative Ethics in More than Human Worlds* (Minneapolis: University of Minnesota Press, 2017), 5.

happened recently in Ljubljana, in the abandoned buildings of the former bicycle factory Rog that had been squatted by activists, social workers, and artists since 2006. Before bulldozers arrived in January 2021 to start tearing down the buildings, and before the police intervened, this was the home of the Rog Social Center, a safe socializing space for refugees and other socially threatened and marginalized communities; people whose work rights, civil rights, and human rights have been violated continually.

Another social enterprise, the Pirate Care Project, founded by Valeria Graziano, Marcell Mars, and Tomislav Medak, seeks to give greater visibility and legitimacy to activists and care initiatives that operate on the margins of the law. Pirate Care is a transnational research project and network of activists, researchers, and practitioners "who stand against the criminalization of solidarity & for a common care infrastructure."[24] They oppose neoliberal policies relating to health care, housing, education, and immigration, bringing together self-organized alternative initiatives that often operate in the "gray zone" between institutional work and civil disobedience. The Pirate Care website cites a number of diverse initiatives that respond to institutional disregard of urgent issues. One of these is the recent Docs Not Cops campaign in the United Kingdom, which includes professionals and patients in the British National Health Service. Among other things, the medical professionals of Docs Not

24 "About," Pirate Care, 2019, https://pirate.care/pages/concept/.

Cops have been refusing to check the documents of migrant patients. Another initiative is the feminist collective GynePunk in Spain, whose laboratory tool kit for emergency gynecological care allows people excluded from reproductive health services—such as trans or queer women, drug users, and sex workers—to carry out their own basic health checks.

These are just two of many significant initiatives to be found on the Pirate Care website, which holds an important archive of compelling examples along with a syllabus for collective study based on the situated knowledge of these practices. Beyond their online work, the project organizers presented the syllabus in Vienna in the 2020 exhibition "... of bread, wine, cars, security and peace," curated by WHW (Ivet Ćurlin, Nataša Ilić, and Sabina Sabolović), who collectively run Kunsthalle Wien. Visitors there could copy the syllabus onto a USB flash drive or access it via a QR code. It's precisely this kind of enterprise that offers a way forward for curators at major international art institutions to present exhibitions that serve as highly visible platforms for activist civil initiatives and extra-institutional social work, while lending such efforts greater legitimacy.

Today's artists and curators are entering territories
that may not have been covered in their professional
training but where, often as nonprofessionals,
they're discovering new ways of maintaining and
modeling a society of solidarity and care.

The pandemic largely closed institutions to
artists and curators. While the internet has been
the main—and sometimes the only—place we've
been able to see art during the various lockdowns
and quarantines, nonetheless the urge to have direct
contact with art persists. There have been projects
in windows, on the facades of buildings, on rooftops,
and in the streets. To paraphrase Beuys, today
everyone is not only an artist but a curator as well.[25]
As the current crisis has shown, the protection of
art can no longer be left solely to institutions that

25 *Jeder Mensch ist ein Künstler* (Every person is an artist) was the
 core thesis for Joseph Beuys and his universalist understand-
 ing of art and the idea that art had to be renewed from the
 ground up. "Every person is a curator / Jeder Mensch ist ein
 Kurator!" was the title of an exhibition at the Moderna galerija
 in Ljubljana, which took place from June 16 to September 30,
 2007. That year, the Moderna galerija, Slovenia's main museum
 for modern and contemporary art, was preparing for extensive
 renovations. Before the renovations started, however, the
 museum invited the public to use its empty spaces. More than
 a hundred artists, filmmakers, cultural workers, and other
 workers, as well as children, responded. They installed their
 own works in the exhibition rooms and thus cocurated an
 exhibition. This exhibition was also a protest against Slovenia's
 cultural politics, since the minister of culture had not
 provided the museum with any funds for its program during
 the renovations.

are increasingly under attack from irresponsible politicians and—the ultimate curator—profit-driven post-Fordist capital. Care for the survival of art must also be the responsibility of the community.

In 2019, as part of the 9th Triennial of Contemporary Art at the Moderna galerija, titled "Dead and Alive" and curated by Vit Havránek, the Slovene artist Ištvan Išt Huzjan presented the dance performance *The Last Kolo*. The kolo is a folk dance common to the South Slavic peoples in which the participants hold hands, dance in a circle, and sing, and thus feel more connected to each other and to the community. In Hujzan's work, the kolo was intended to strengthen a sense of belonging to the local art community. His original idea was for each participant to hold a painting or some other kind of artwork so there would be one artwork between every two dancers. In the end, however, the kolo circled around half of the museum building and it wasn't possible to use very many artworks. So, for practical reasons, instead of paintings, Huzjan gave the kolo dancers sticks to hold. These weren't just ordinary sticks; in a way, they were also artworks. For Huzjan appropriated the idea of collective stick holding from a performance the OHO group made in 1970, *The Blind and the Seer*. In that work, OHO members walked single file with their eyes closed, holding sticks that linked them together and concentrating on everything they were experiencing through their other senses. In *The Last Kolo*, Huzjan entrusted these artworks to the care of anyone and everyone who came to the performance

and participated, who felt joy in the work yet were not called to be professional custodians of art. Curatorship—the act of care, as in the Latin derivation of the role of the curator as a caregiver—took on a broader sense that melded art, care, and community as one.

Huzjan's work should be understood in the context of the specific conditions in Slovenia, where the directors of the country's leading cultural institutions were replaced for political reasons in 2020, where artists who criticize the government are threatened, and where it's now necessary for the art community to close ranks and take the care and protection of art into their own hands. This is what Huzjan did when he gave the dancers art to hold and, clapping his hands, encouraged them to sing. But people aren't singing today the way they did in earlier times, and only humming comes from the mouths of the dancers. Such are the unannounced voices that must now be heard.

As the political situation in Slovenia worsened in 2020, with the government not doing enough to help artists left without income during the pandemic, the sound artist Tomaž Grom made a performance that took its title from a quote by Martin Luther: "A happy fart never comes from a miserable ass." Grom invited one hundred artists to send him recordings of their farts. He paid each of them twenty euros to make the point that the participating coauthors of the project—the workers—needed to be paid. Not unlike farting, art in the current climate isn't viewed, at least where I

live, as beneficial to society. In fact, the only thing the present Slovenian government knows to do with socially critical contemporary art is to try to suppress it.

Grom made a sound installation from the collected farts and placed it on an exterior wall of the Museum of Contemporary Art Metelkova in Ljubljana. The museum stands in the immediate vicinity of the Ministry of Culture, where artists held weekly protests in 2020 against the government's cultural policies. While most of these protest performances directly accused the government of failing to provide cultural workers with adequate support during the pandemic, Grom counted on embarrassment and humor to make his point. A fart is a human sound that doesn't in itself overlap with any meaning. But the farts in Grom's piece sent a clear message. One of the key words in Slovenia recently has been *sramota* (shame), written countless times in protest graffiti and repeated in numerous public statements from cultural workers and intellectuals. Farts are something we are ashamed of—especially when they escape us in public—and in an artwork, farts always play on embarrassment, which is why they figure in so many jokes. Like humor in a Chaplin film, farts are able to connect people without them needing to understand any complicated discourse or symbols. All of this figured in Grom's mischief, joining politics to humor, humor to outrage, outrage to community.

In Mladen Dolar's writing about the linguistics of the non-voice, he includes sounds that come from

our mouths against our wills, such as coughs and hiccups. With the non-voice, he says, we're dealing with the intrusion of physiology into structure, of nature into culture. But any sound that comes from a human being also addresses something; consequently, there's no human sound that couldn't also be speech, in which the great Other isn't already present and presumed as the general addressee.[26] Given that the fart is considered to be our most "animal" sound, it's also the sound we most try to control. Yet the more it's controlled, the more meaning it has.

So the answer to the question of how the pandemic will affect the future work of curators and artists must be sought in places where there appears to be no answer, no expected voice—in humming, in sounds that have little to do with the existing norms of language.

The pandemic has made us afraid to touch, hug, and kiss. Many who have analyzed the social and psychological effects of the pandemic tell us how imperative it is to resensitize our bodies, especially in relation to other bodies. Of course, the reactivation of the body isn't only connected with emotions and pleasures; we should also consider our total expression within social reality. And in all of this, we must not wait for someone to put in place the right conditions before we can experience life to the fullest. We must look out the window onto the street, where our bodies are already activated, where we are already touched by activism. But nature,

26 Dolar, *A Voice and Nothing More*, 23–29.

too, is an activist, and unfortunately it speaks at the moment through a pandemic. If our galleries and museums become even more aseptic, and if the distances we keep from each other become ever greater, all we'll have left are the open spaces of nature and the street, where we've already been raising our voices. Curatorship after this global catastrophe will undoubtedly be less self-involved, dealing with institutional critique or revisions to art history. Instead, it will be more focused on people, here and now. We'll ask ourselves more urgently who our exhibitions and projects are intended for, and what the best formats are for our work, if we want to improve the world.

For more than a year now, the questions at the forefront of curatorship have become: Where are we situated? How are we positioned? How can we "unmute" those who can't unmute themselves? How can we stop just interpreting the world and begin to change it? We have to avoid the kinds of interpretations that alienate us from our own voices. Changing the world requires us to develop fields of resonating voices that don't, won't, and can't fully overlap with existing meanings. The voices of change always come unannounced. And change is what this is all about.

Zdenka Badovinac is a curator, writer, and director of the Museum of Contemporary Art in Zagreb. From 1993 to 2020 she was director of the Moderna galerija, comprised of the Museum of Modern Art and the Museum of Contemporary Art Metelkova, in Ljubljana. She initiated the first Eastern European art collection, Arteast 2000+, which subsequently became the core collection of Metelkova. She recently curated "Bigger than Myself: Heroic Voices from Ex-Yugoslavia" at MAXXI, the National Museum of Twenty-First-Century Arts, in Rome (2021). Her most recent book is *Comradeship: Curating, Art, and Politics in Post-Socialist Europe* (New York: Independent Curators International, 2019). Badovinac was among the founders of L'Internationale, a confederation of seven modern and contemporary European art institutions. She also served as president of CIMAM, the International Committee for Museums and Collections of Modern Art, from 2010 to 2013.

Thoughts on Curating, volume 2

Zdenka Badovinac
Unannounced Voices:
Curatorial Practice and Changing Institutions

Published by Sternberg Press

Editor: Steven Henry Madoff
Translation from the Slovene: Rawley Grau
Copyediting: Anita Iannacchione
Proofreading: Max Bach
Design: Bardhi Haliti
Typeface: Magister (Source Type)
Printing: Printon, Tallinn

ISBN 978-3-95679-584-8

Distributed by The MIT Press, Art Data,
Les presses du réel, and Idea Books

MA Curatorial Practice
School of Visual Arts
132 West 21st Street
New York, NY 10011
www.macp.sva.edu

Sternberg Press
71–75 Shelton Street
London WC2H 9JQ
United Kingdom
www.sternberg-press.com

Thoughts on Curating
Series edited by Steven Henry Madoff